Copyright © 2016 Carrie Lowenstrom

Melissa Deanching

All rights reserved.

ISBN:13:978-1532953224
ISBN:10:1532953224

We dedicate this art, story book : A Child's Day to the lights in our lives, Ella Kate, Sophia Marie, Gennavieve Susan, Analise Jordan, Shawn Anthony, Paisley Shae, and Maximus Alexander.

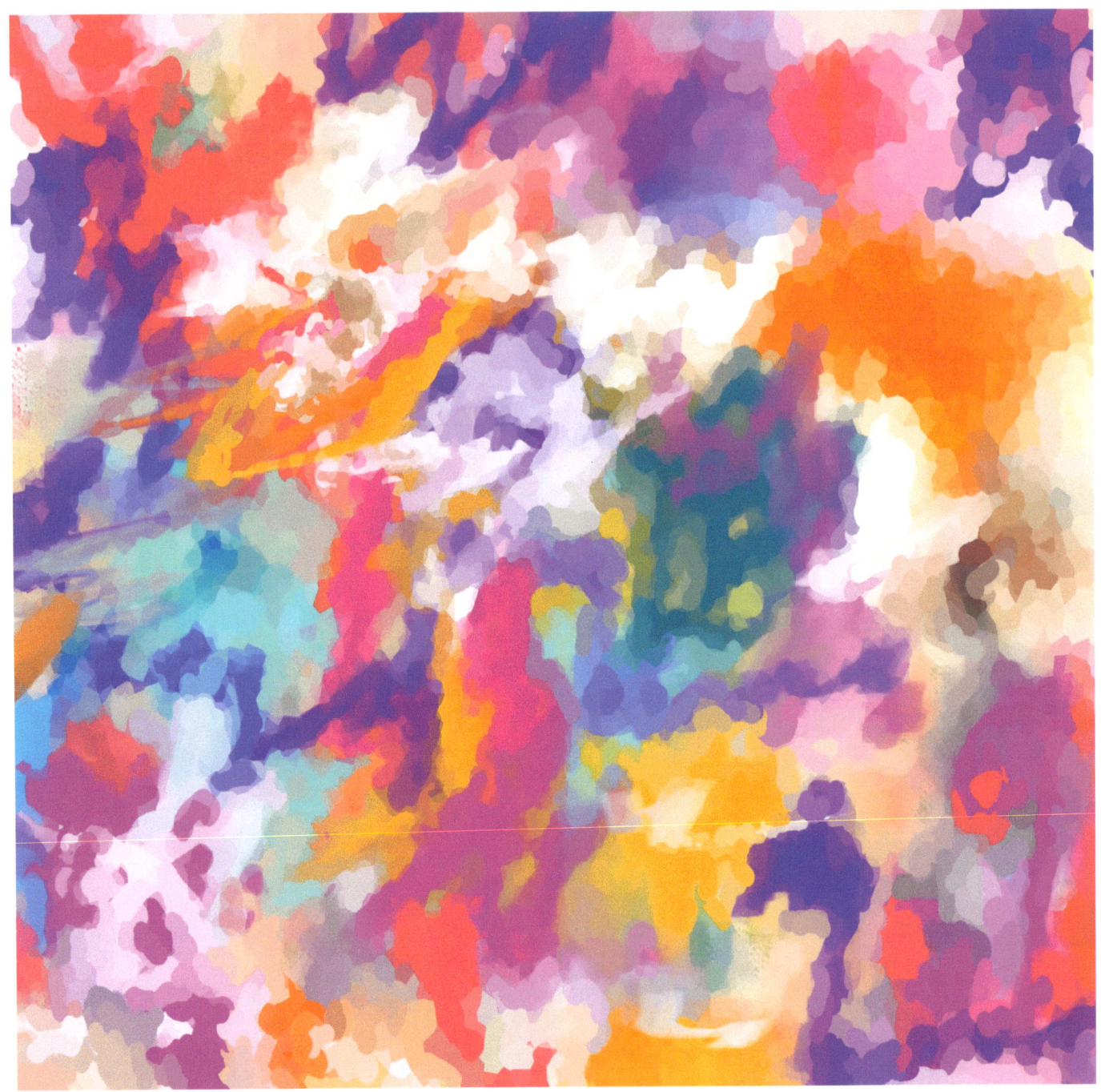

Sunshine wakes up little toes.

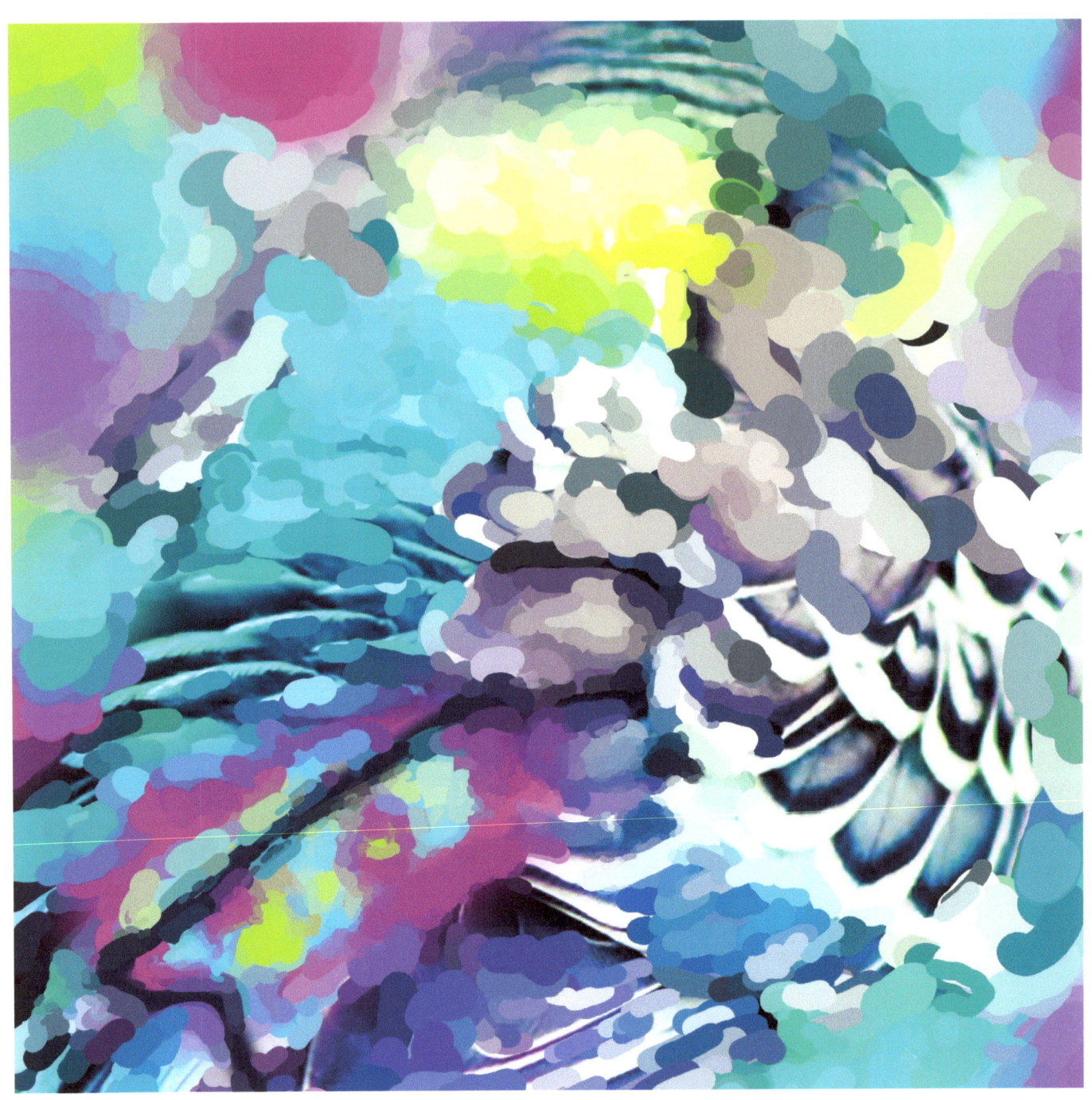

Assorted blankets brushed aside.

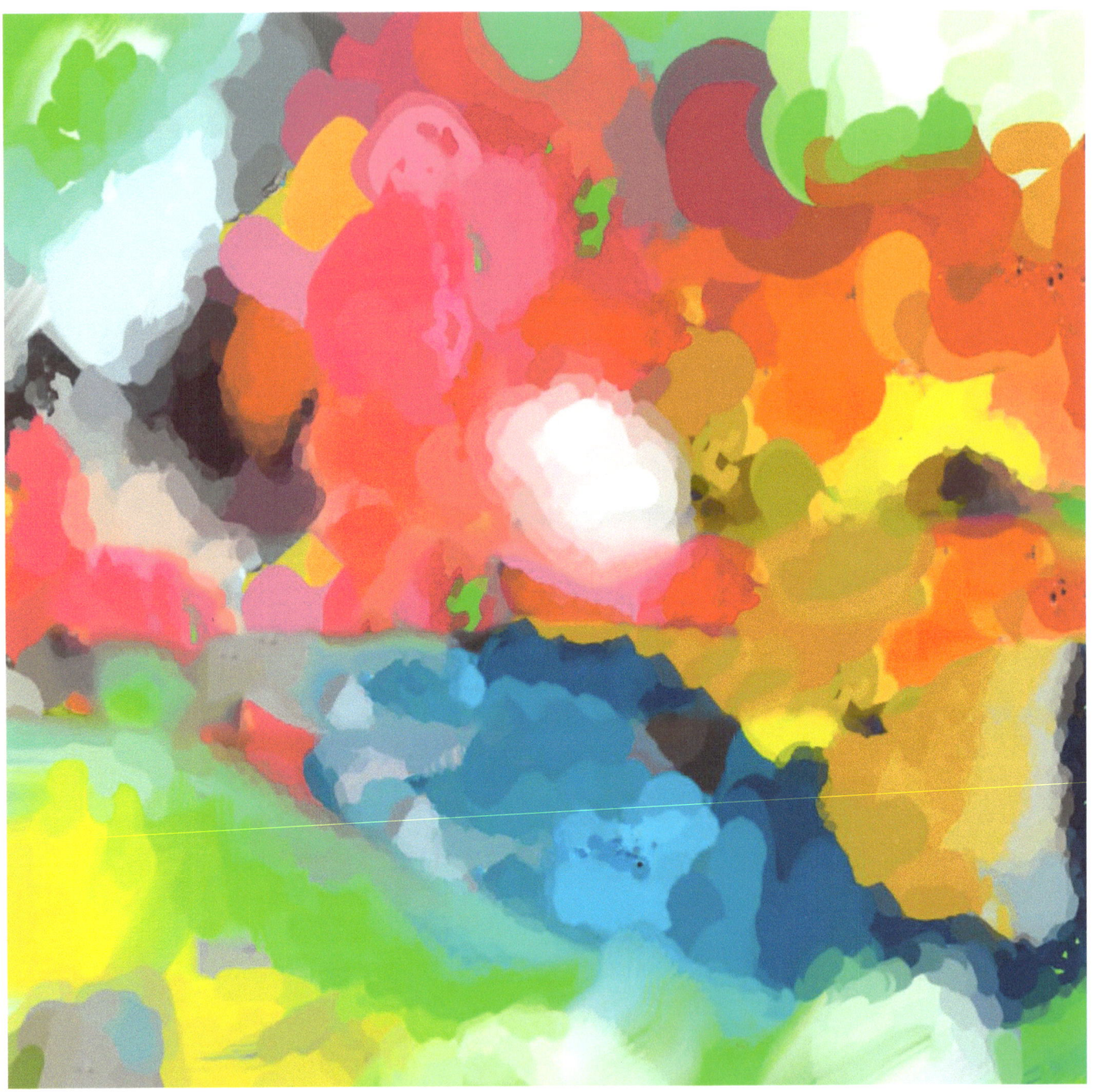

Crayons line the table.

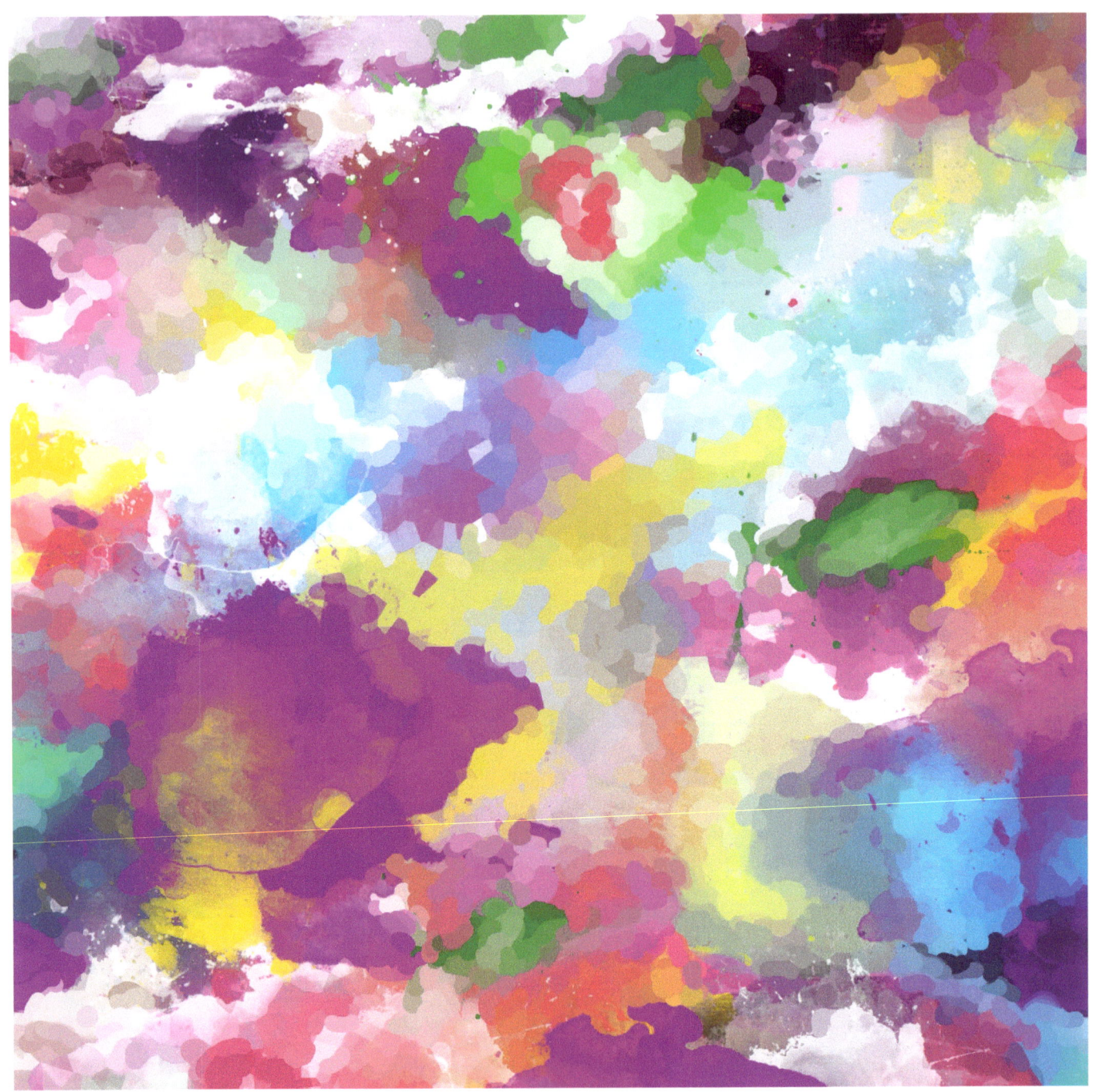

Stuffed animals sit in a chair to watch.

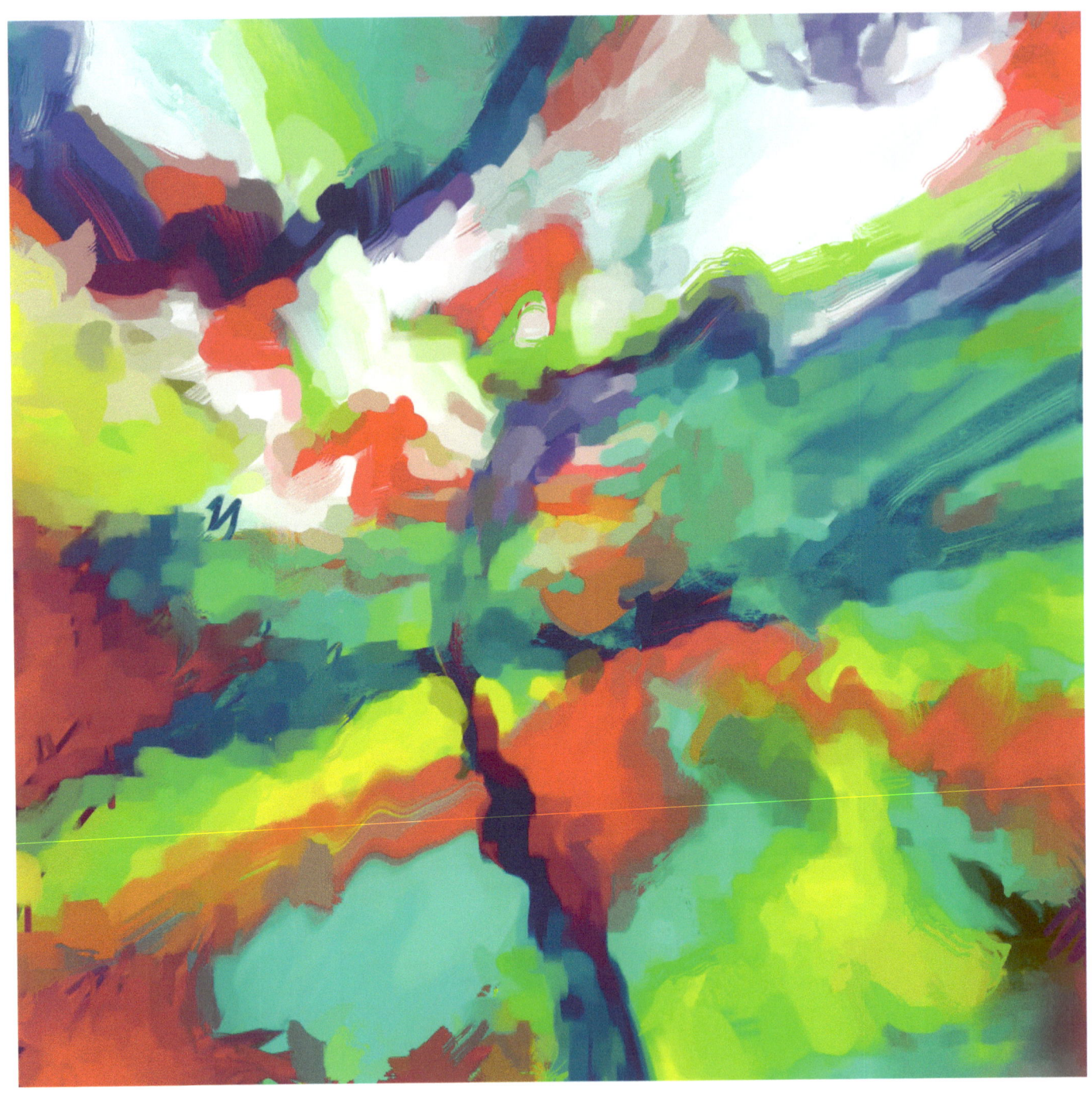

Paper airplanes hang by strings.

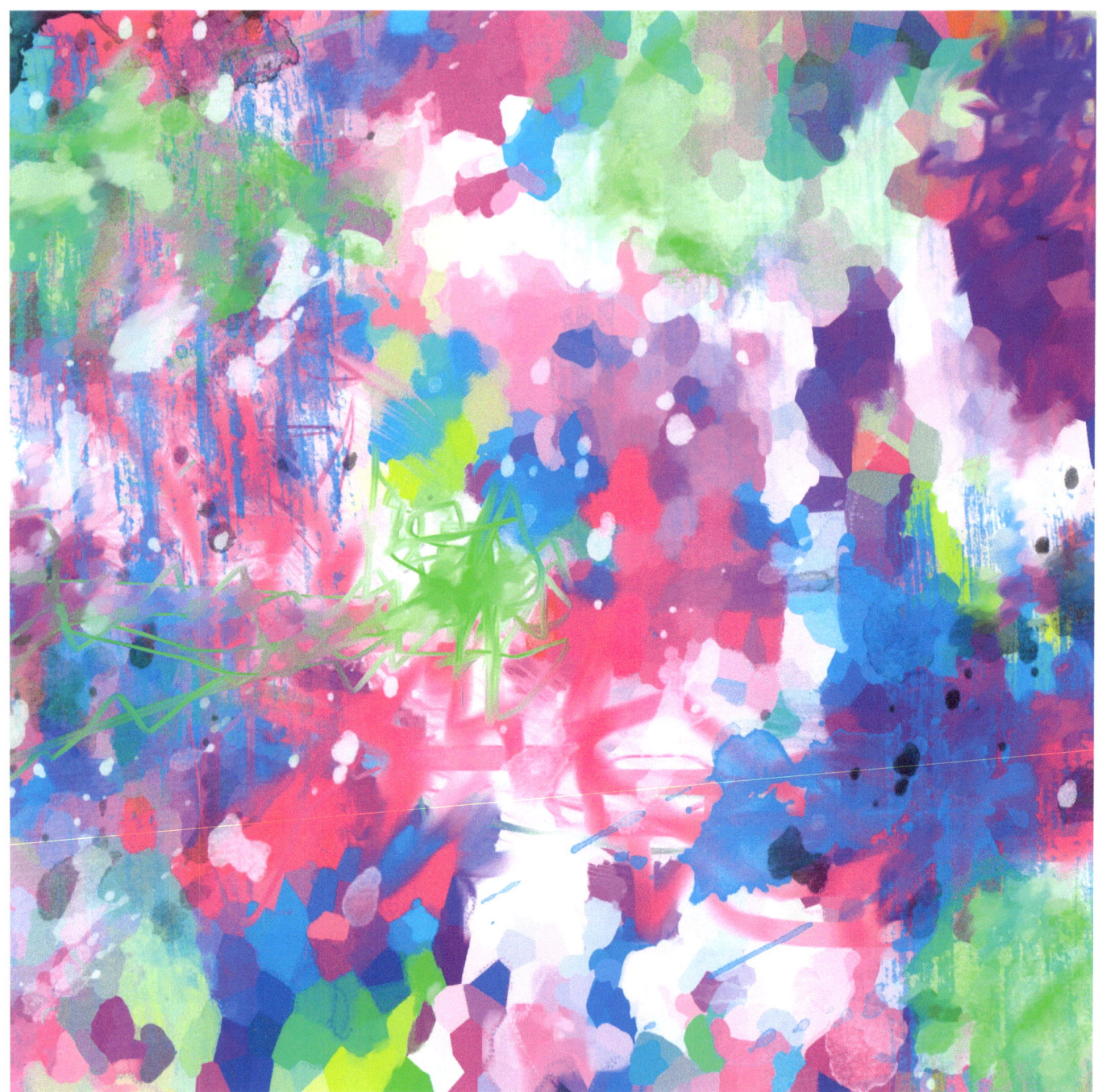

Glitter scatters around fairy wings.

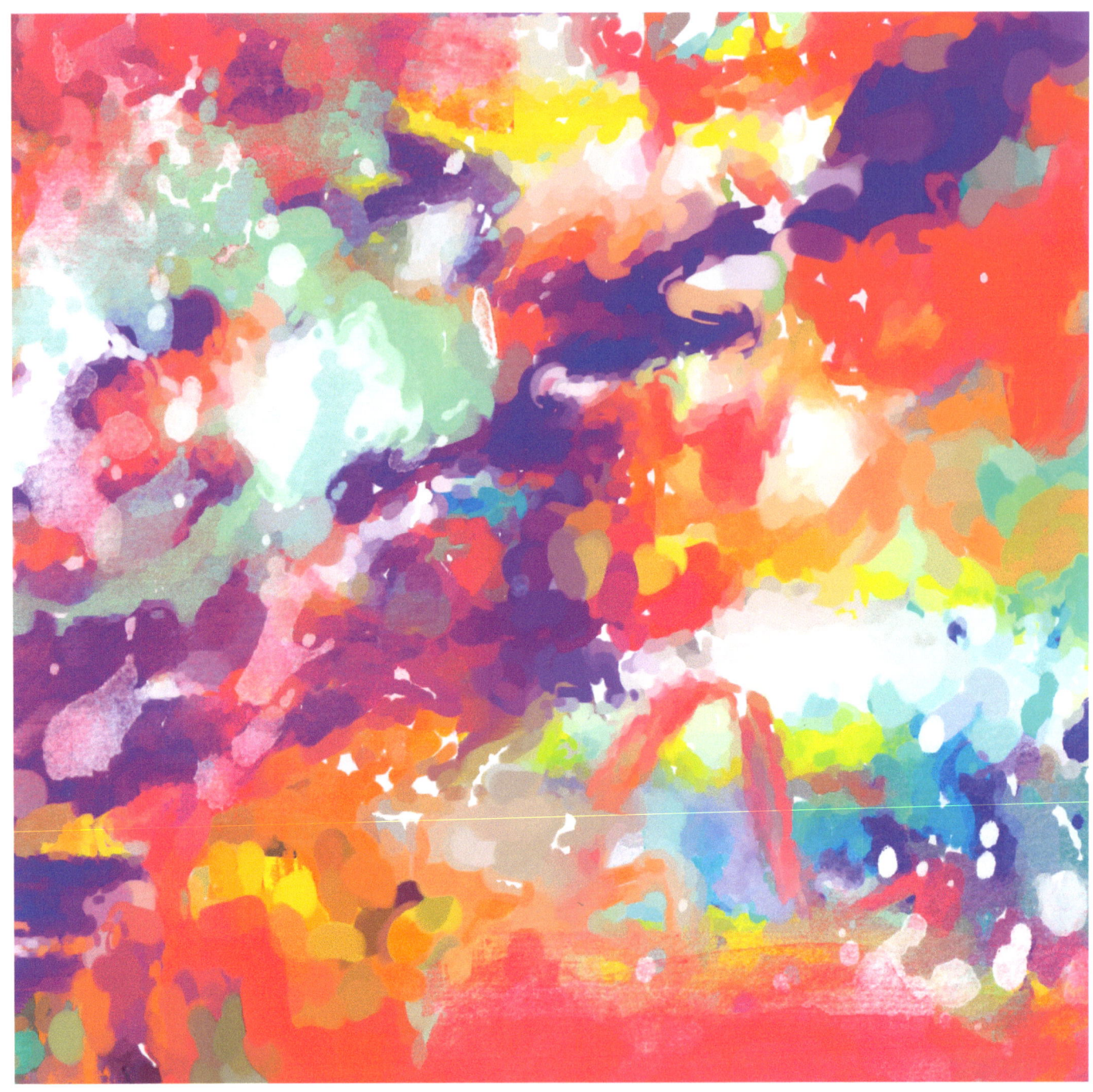

Cotton balls swirl on a paper project.

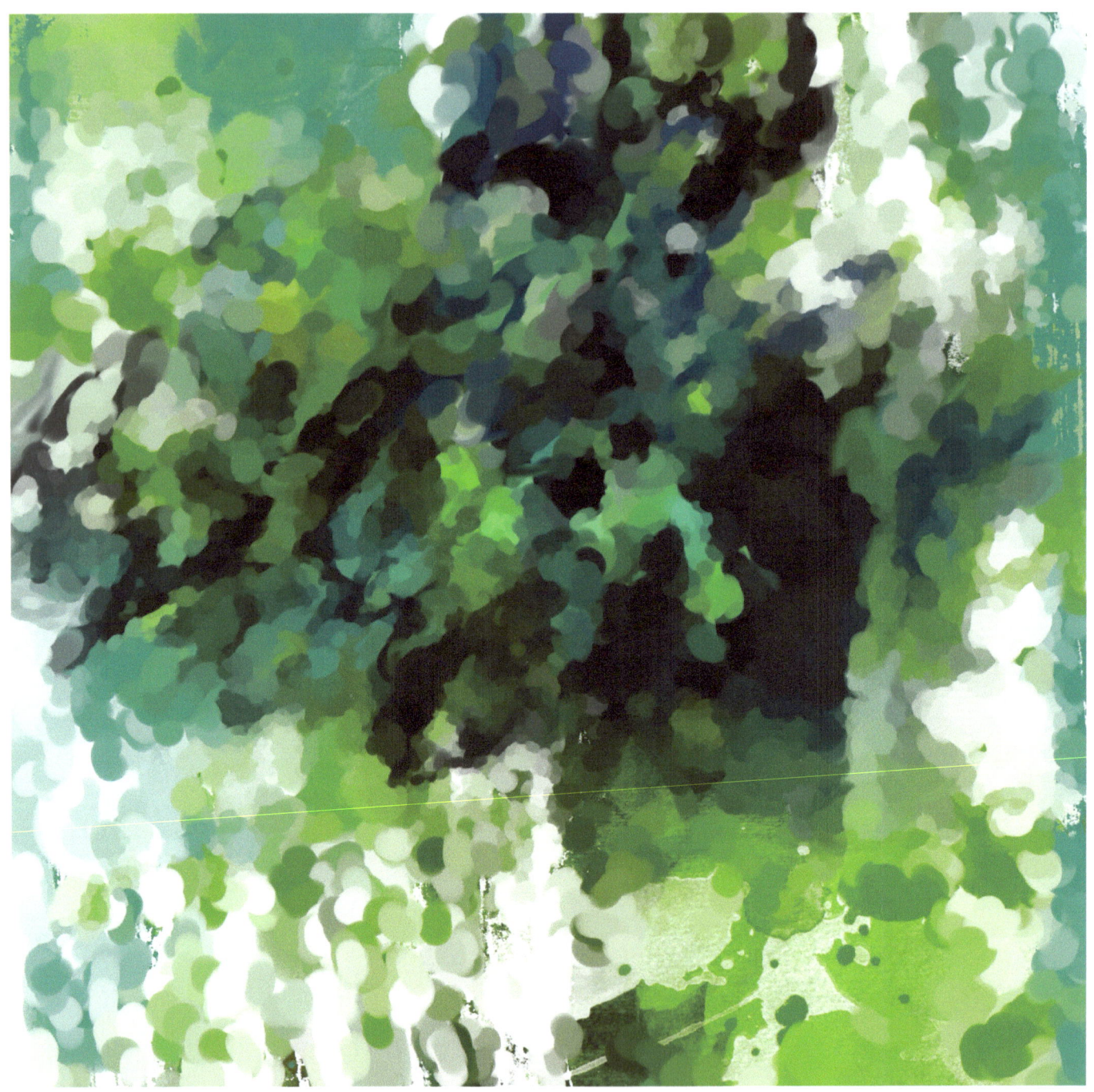

Plastic dinosaurs growl at each other.

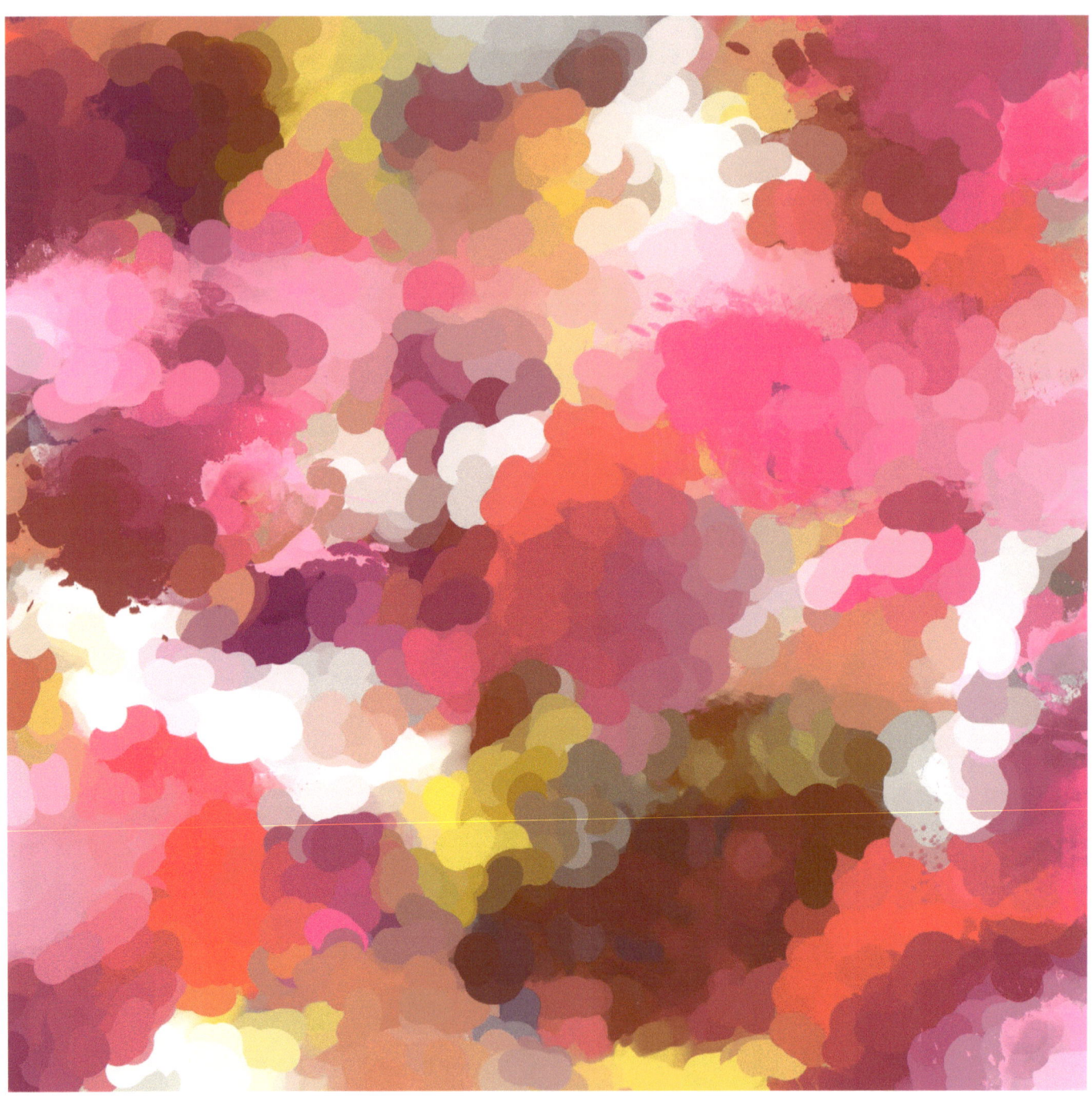

Indian dolls with braids hold hands.

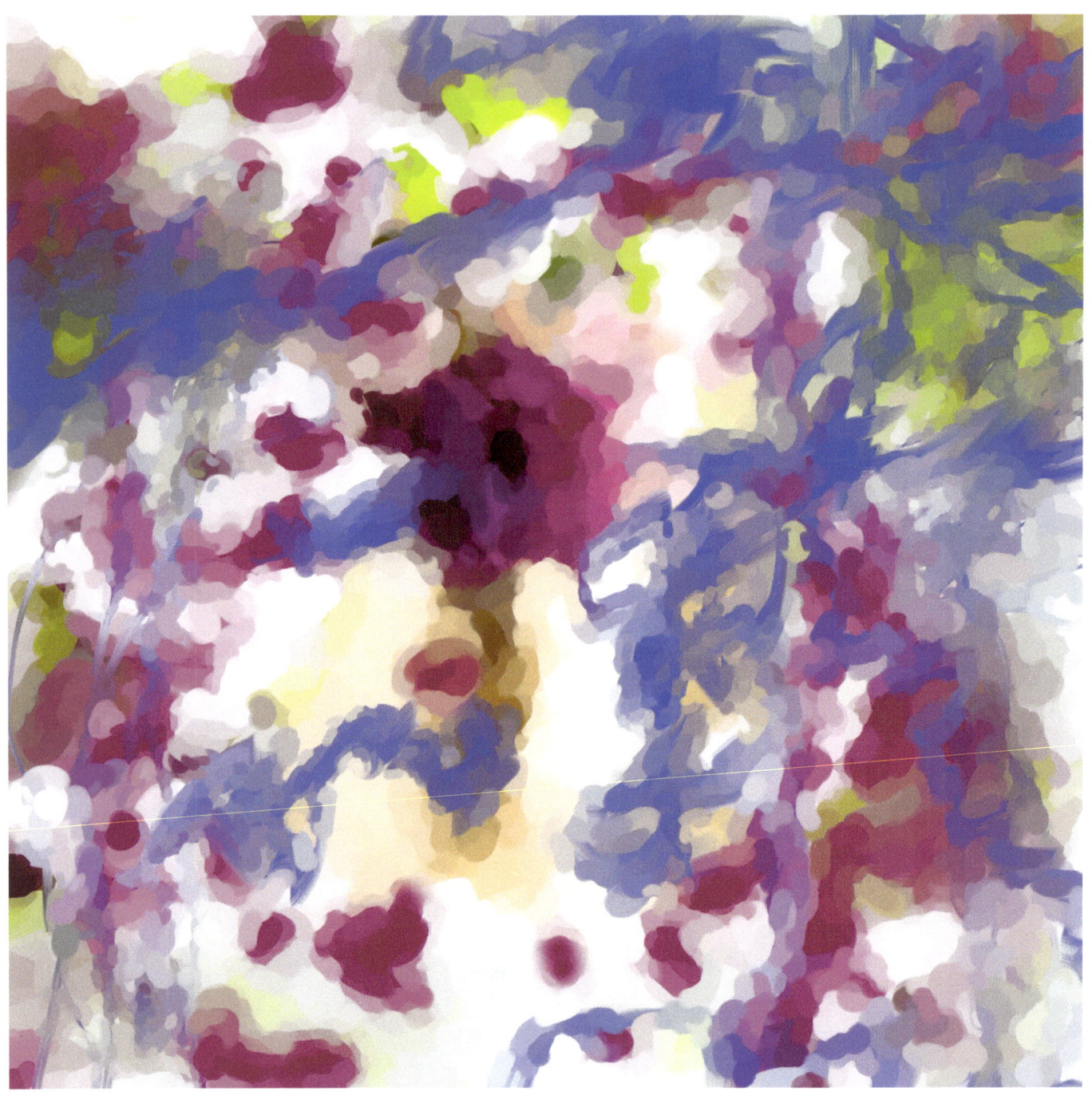

Puzzle pieces make a cake.

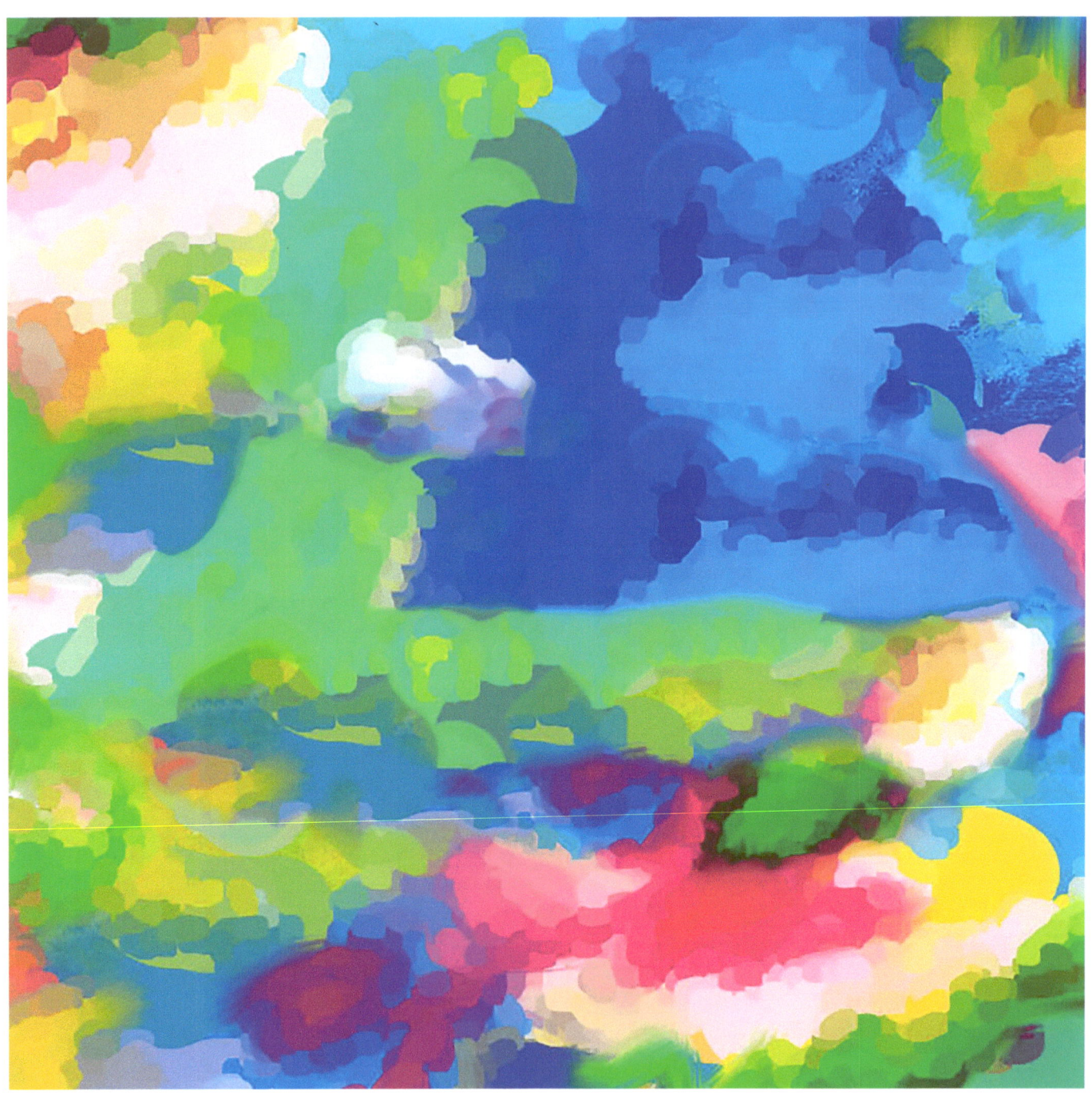

Ships sail in a sink.

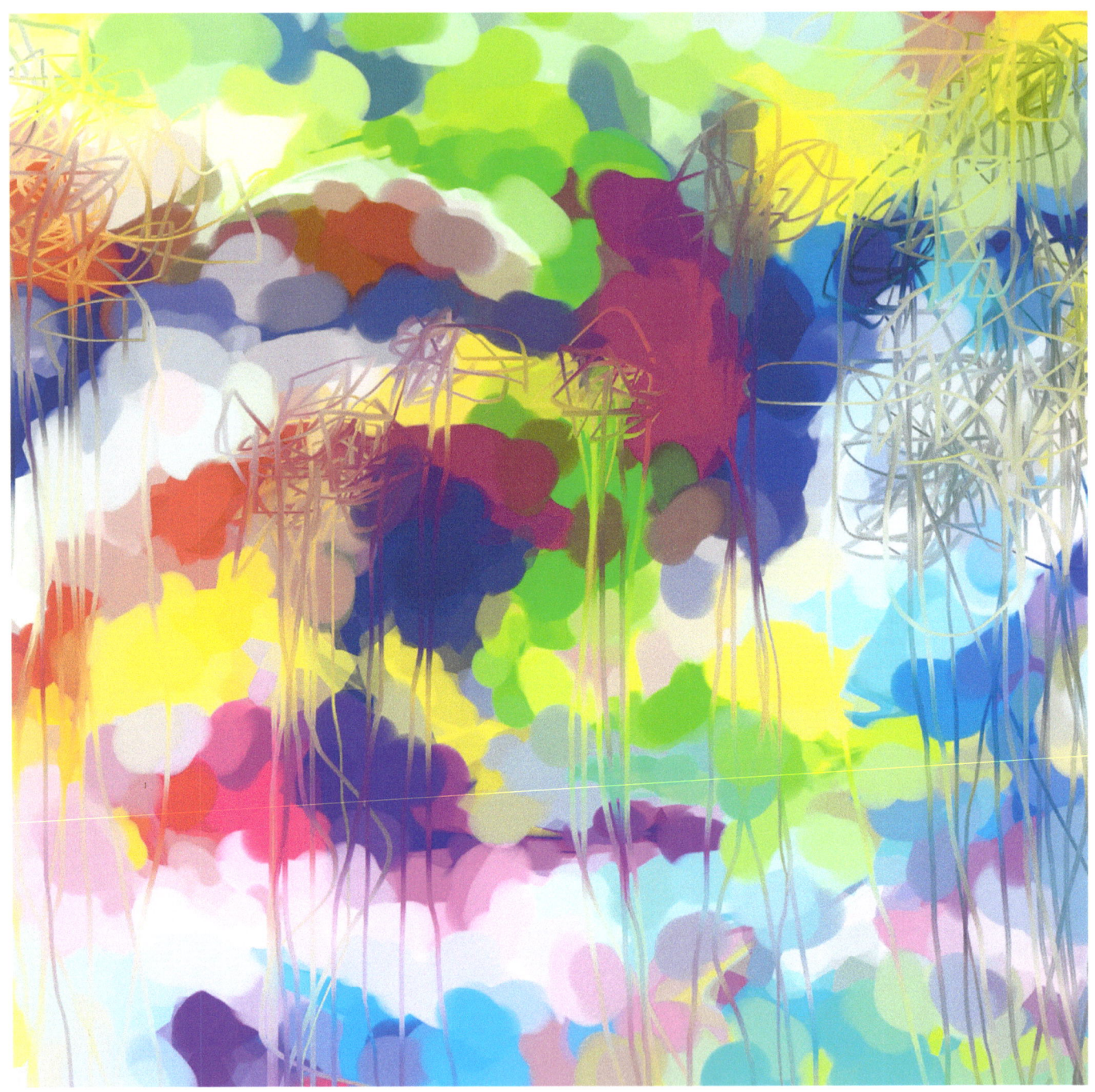

Straws in silly shapes sit in a jar.

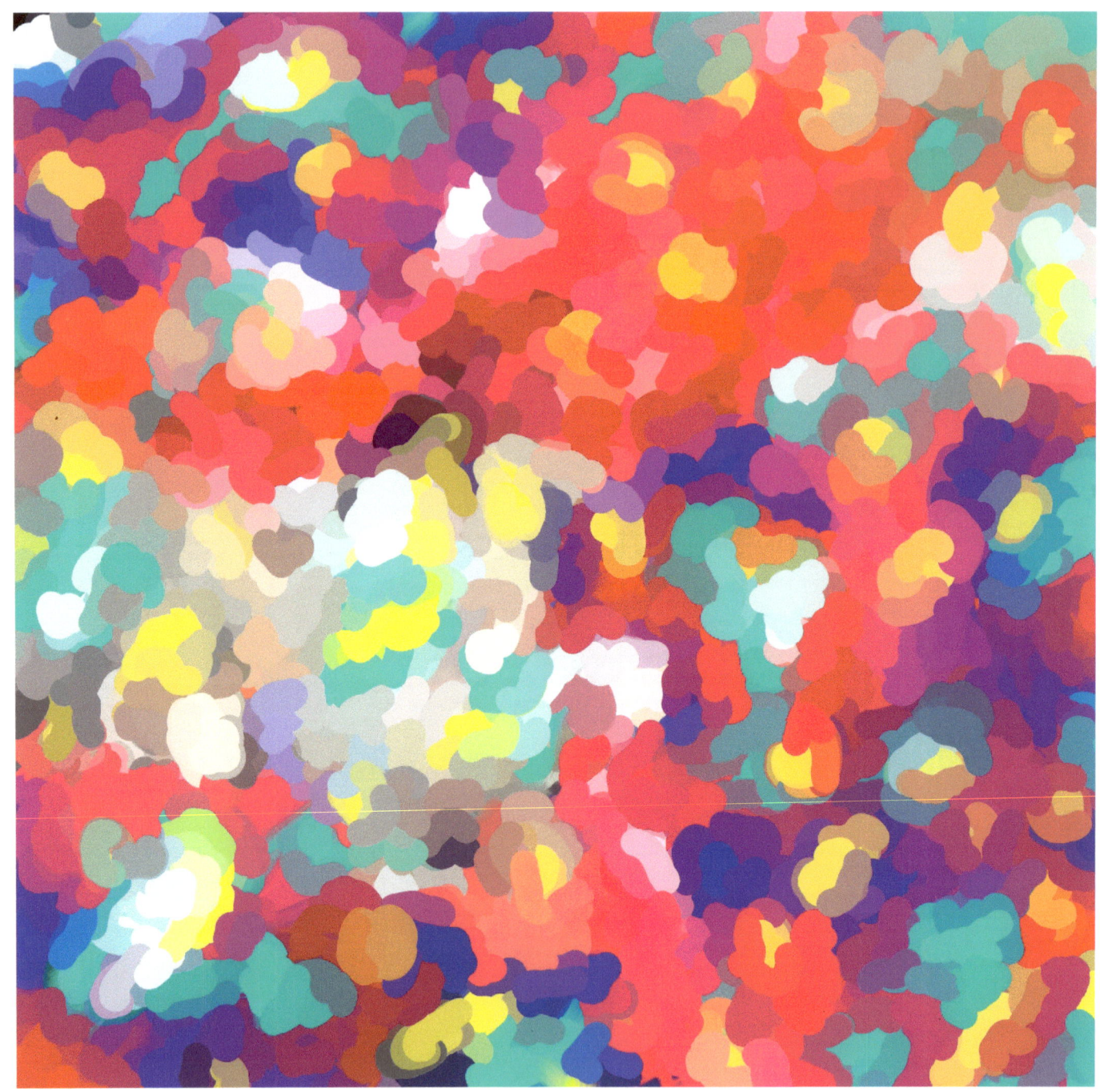

Numbers and ABC's scatter along a chalkboard.

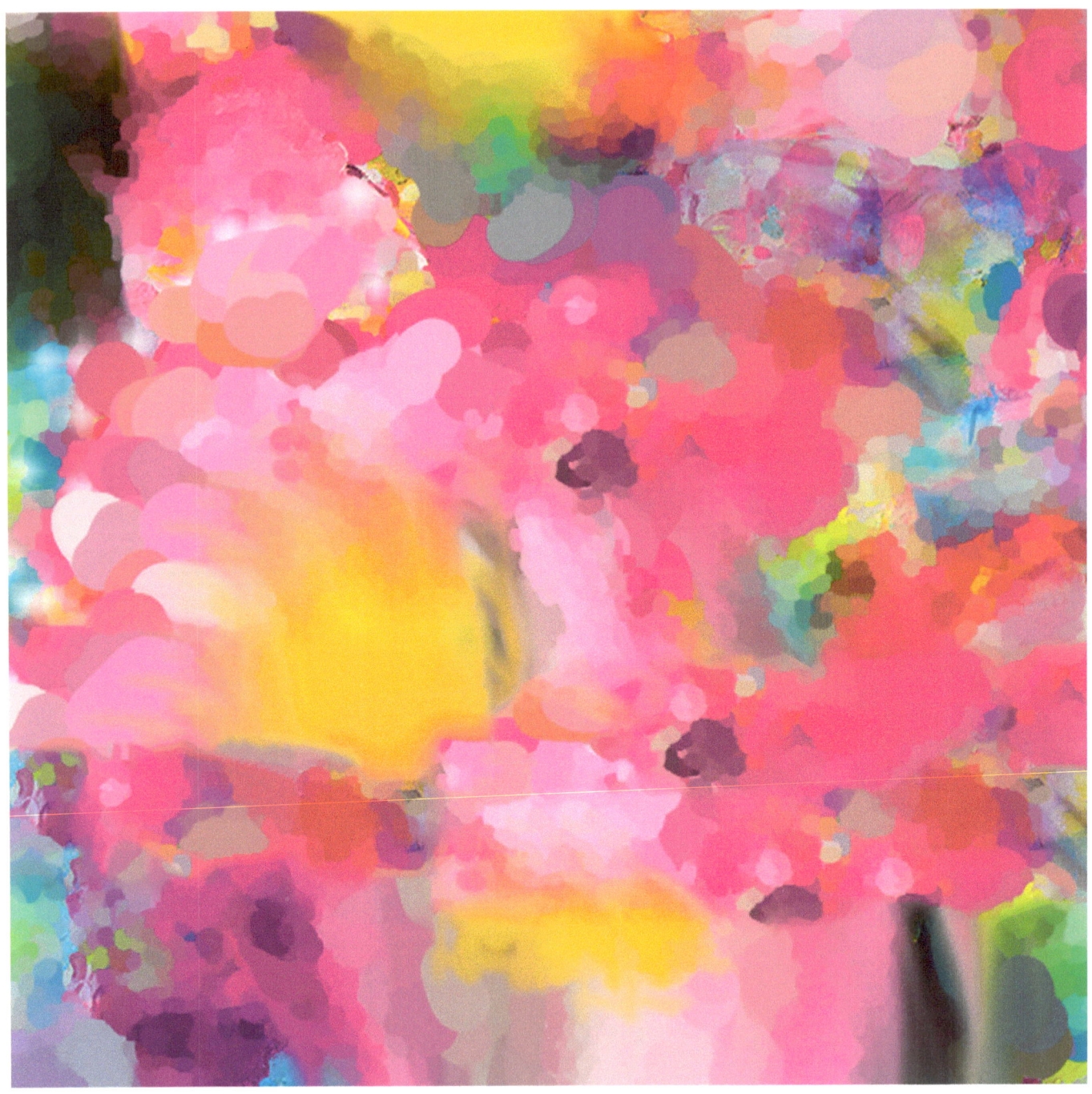

Wind up chicks chirp by a window.

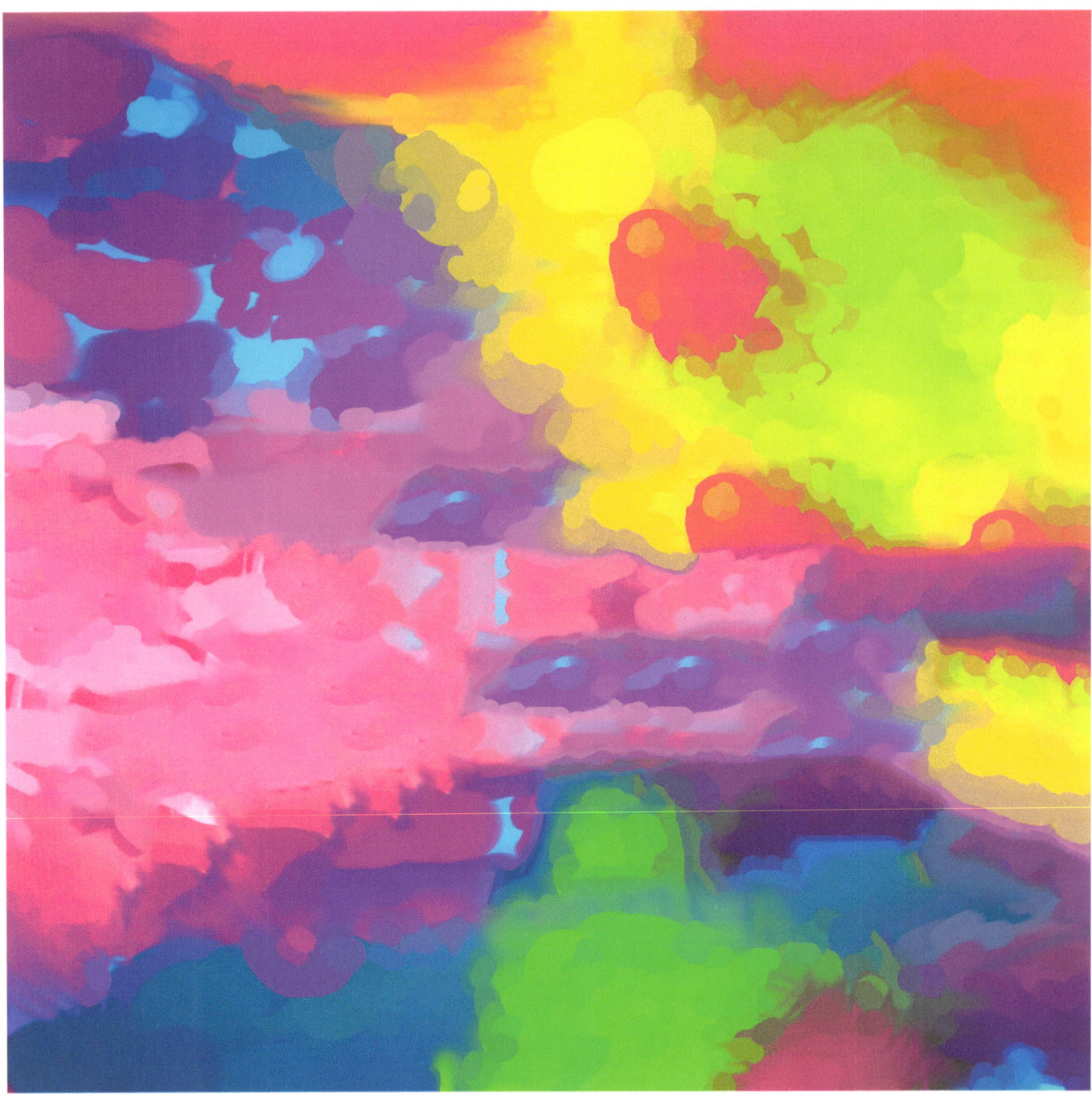

Pinwheels blow in a breeze.

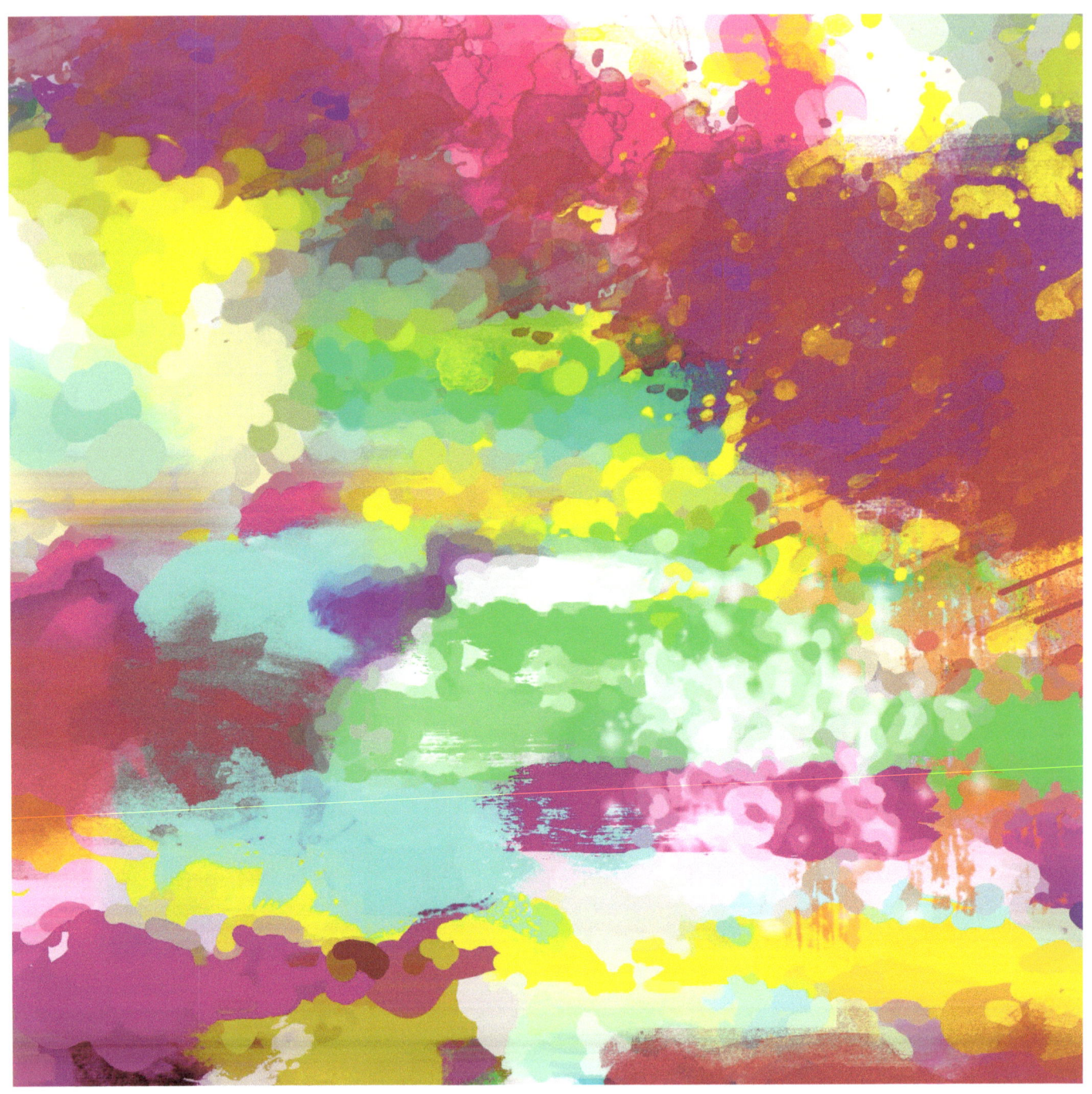

Paint drips from a collage.

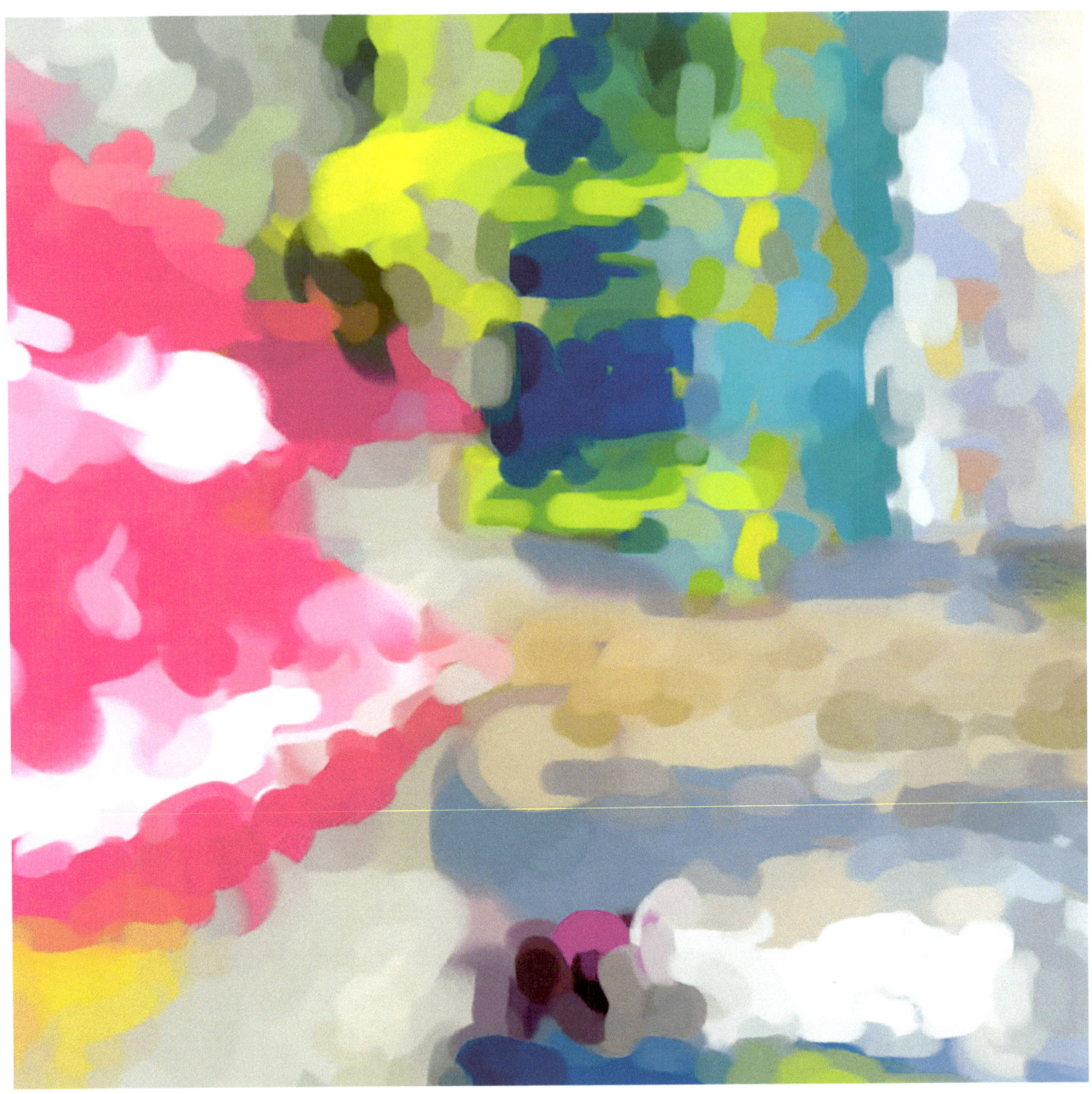

Bubble wands stick out of a bucket.

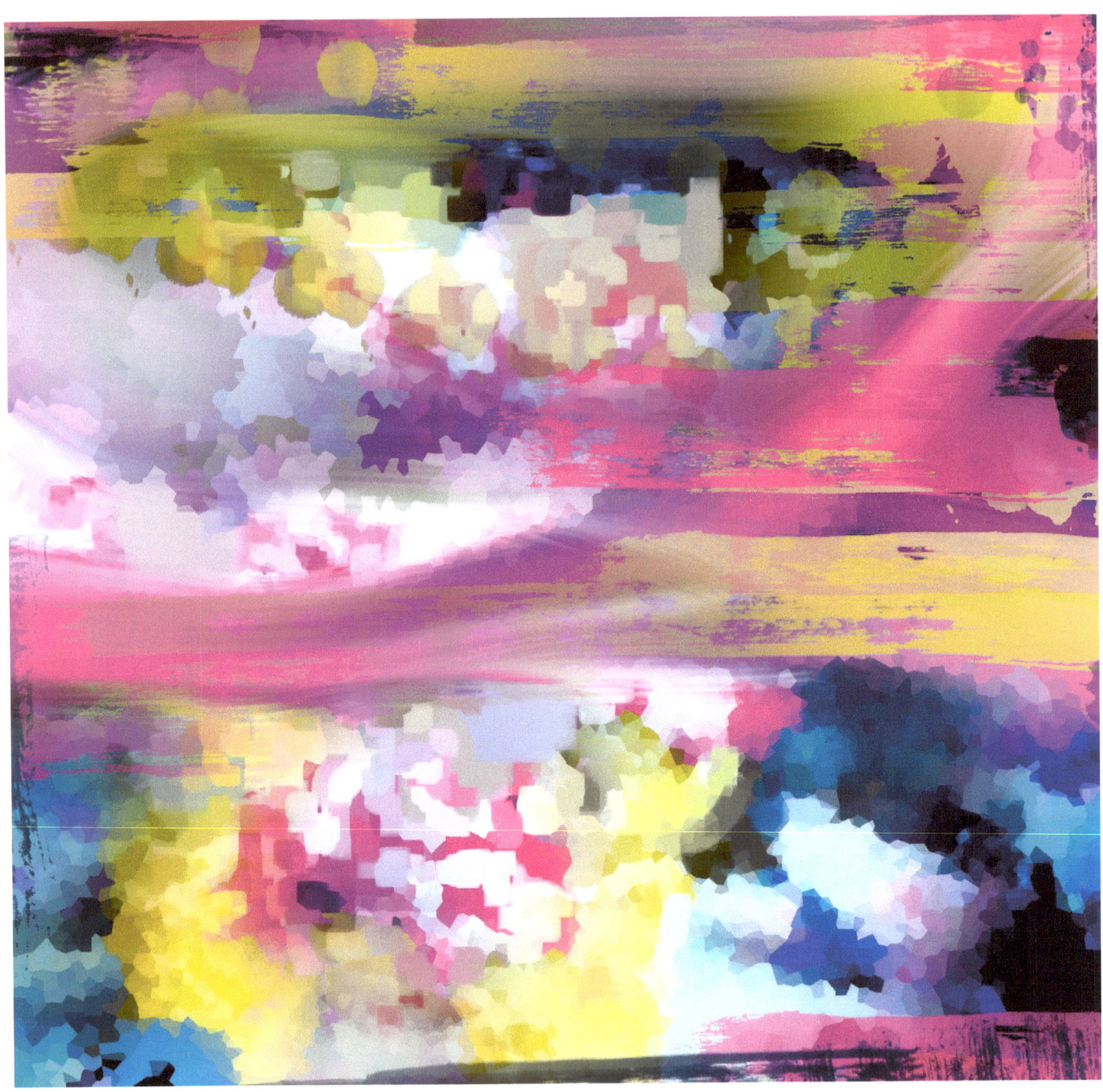

Foam stars line a pattern to the floor.

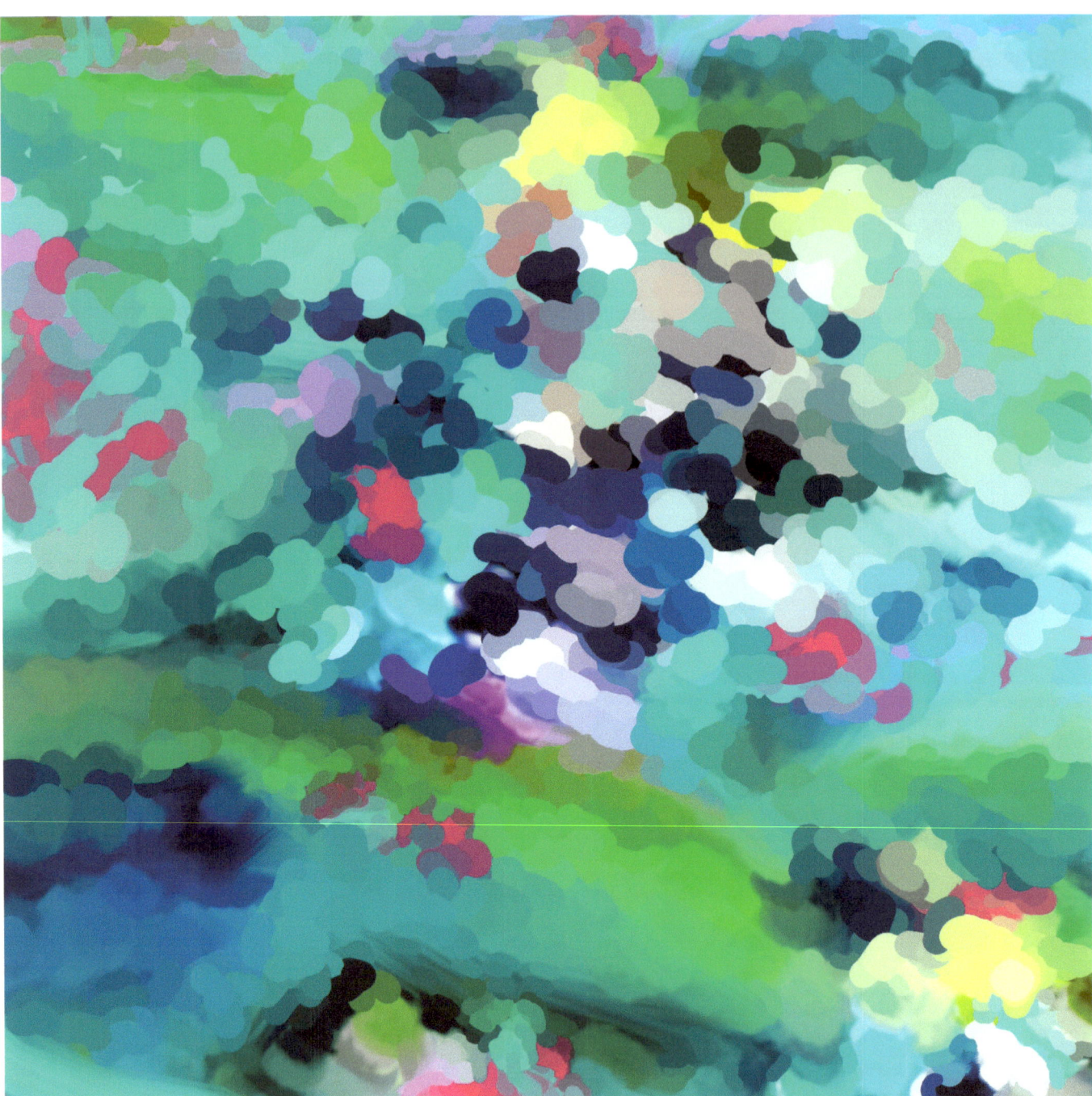

Blankets become tucked and neat.

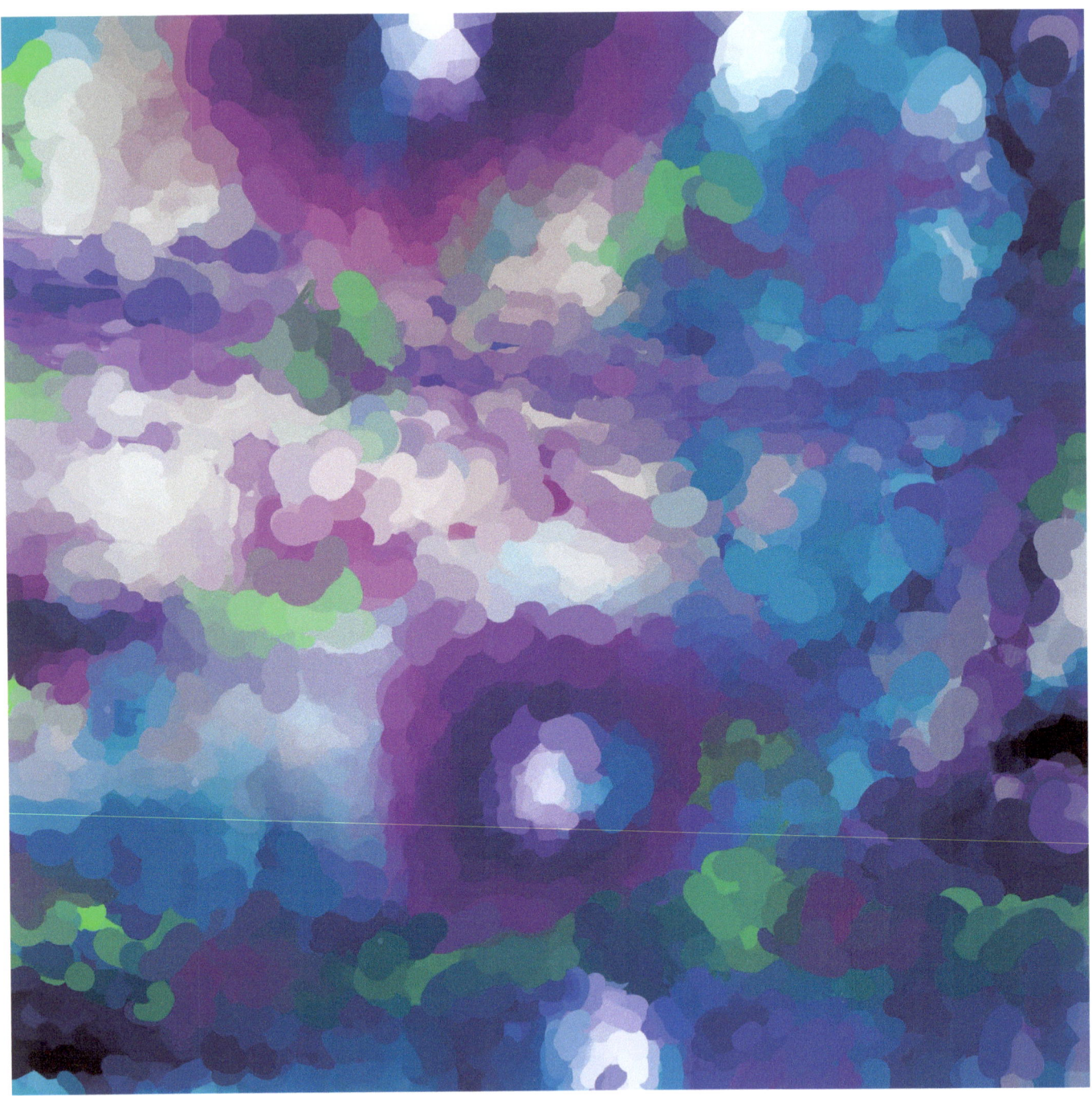

Moonlight dances to close eyes.

Art by Melissa Deanching

www.heybeautiful.photography.com

instagram @mdeanching

Author – Carrie Lowenstrom

www.ingramcontent.com/pod-product-compliance
Lightning Source LLC
Chambersburg PA
CBHW050832180526
45159CB00004B/1877